For John ❧
I love you more than cake.

Et pour ma grandmère et ma famille ❧
Parce que, parce que je vous aime.

P.S.
This book was brought together
by a most magnificent team
of enthusiasts.
Thank you, dear hearts.

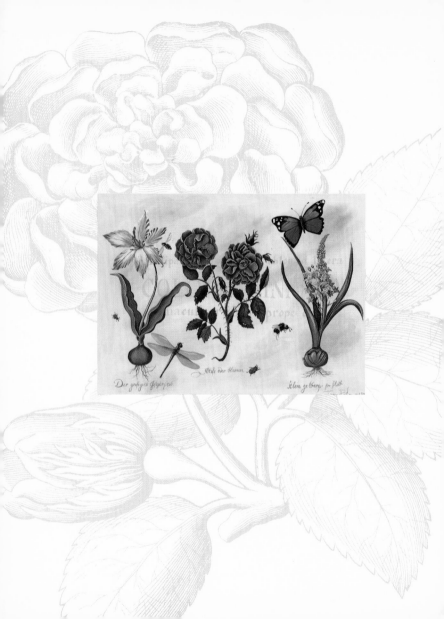

Returning Home

The Poetics of Whim & Fancy

Created by
TRACY PORTER

**Andrews McMeel
Publishing**

Kansas City

WITH WRITING BY
PATRICK REGAN,
DUKE CHRISTOFFERSEN,
AND JOHN PORTER

PHOTOGRAPHY BY
DEBORAH FLETCHER
AND MAURA KOUTOUJIAN

ISBN: 0-8362-3178-3

Returning Home

The Poetics of Whim & Fancy

I've long thought it peculiar that people will freely substitute the words "home" and "house." To me, one is an empty canvas; the other a soul-revealing portrait. One a ream of blank paper; the other a masterpiece of literature. Home is an unceasing experimen into the temperament of beauty---capturing

it, focusing it--- and releasing it for reinterpretation. Home is sanctuary, inspiration, and a living tribute to all of life's shared and personal glories, as well as its quiet moments of reappraisal, even sorrow. Home is a reflection of my loves, my spirit, and my soul. It is not merely where I live; it is where my life is.

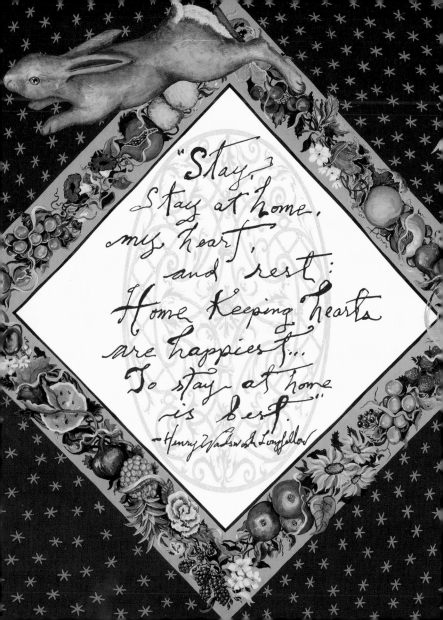

"Stay,
Stay at home,
my heart,
and rest:
Home Keeping hearts
are happiest...
To stay at home
is best."
—Henry Wadsworth Longfellow

Arriving home from a journey or from a day's work holds a restorative power that humbles me. Home welcomes me no less than if it had two strong arms to embrace me, and when I cross that threshold sometimes I linger there to breathe in its assuring welcome. All that I know is hanging in the air here. Light filters in through windows and falls lazily on every surface, defying the insistent metronome of the mantle clock, moving at it's own imperceptible pace. Shadows and light and familiar patterns ... home soothes me and buffers the biting winds of the world. ❧

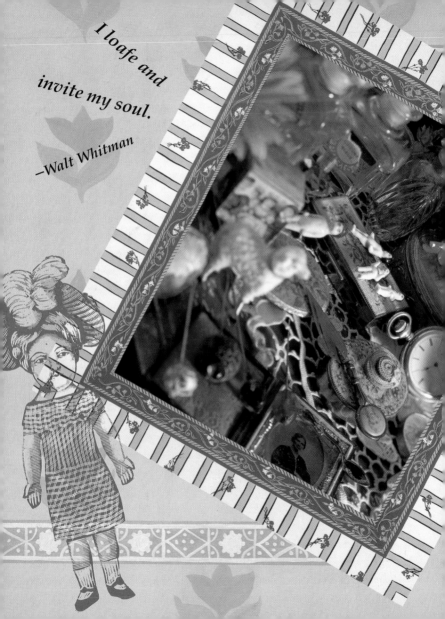

I loafe and
invite my soul.

–Walt Whitman

Perfecting the Art of Puttering

It's about every-thing involved with the **creative** process. Fiddling until it feels right. Walking away. Coming back. Fiddling again. It's about letting thoughts and inspirations enter your mind freely. It's about putting things together that you thought didn't make sense ... yin & yang. It's about finding things from past and present, mixing them up and seeing how **magical** creating is.

Lately I have been thinking about how comfort is perhaps the ultimate luxury.

—Billy Baldwin

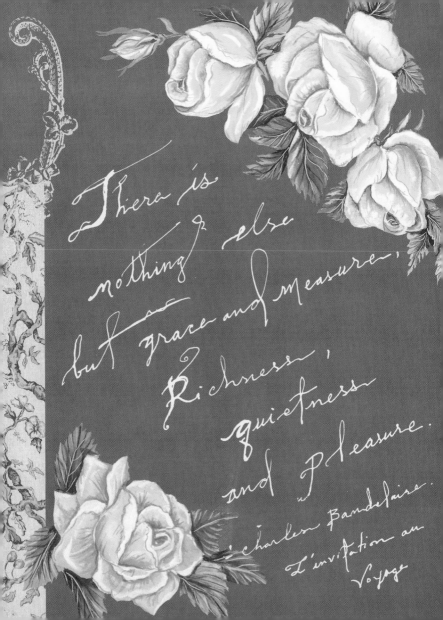

There is
nothing else
but grace and measure,
Richness,
quietness
and Pleasure.

"Charles Baudelaire,
L'invitation au
Voyage

The appearance of the little sitting-room as they entered was tranquility itself...

"this is a pleasure," said he, in rather a low voice.
— Jane Austen, *Emma*

To be **happy** at home

is the ultimate result

of all ambition,

the end to which every enterprise

and labour tends.

–Samuel Johnson

Every spirit builds itself a house,
and beyond its house a world,
and beyond its world a heaven. Know then that the wor

Sacred space and sacred time and something joyous to do
is all we need. Almost anything then becomes
a continuous and interesting joy.

– Joseph Campbell

...ists for you.
Emerson

Homes are full of memories. Some are created as a house gradually blossoms into a home; Others travel with us in cardboard boxes full of mementos we cannot bring ourselves to throw away. When we moved into our farmhouse, I would lose hours meandering through the memories contained in a single box. During one such foray, I came upon a fabric swatch from my grandmother's grey dress. She lived with us on the farm where I grew up. She is French and has a French woman's passion for food and cooking (and for life en tout!). I close my eyes and can see her standing in the small kitchen of her "apartment" (formerly our garage) in her apron and the grey dress. She has allowed me a sip of wine with dinner, and we are tasting a beef bourguignonne of her creation. We laugh and eat. Very French. Holding that care-worn swatch of fabric in my hand, I relived an entire winter evening in a single moment.

It's not the houses
I love, It's the life
I live in them.

– CoCo Chanel

I'll note you
in my book of memory.

William Shakespeare

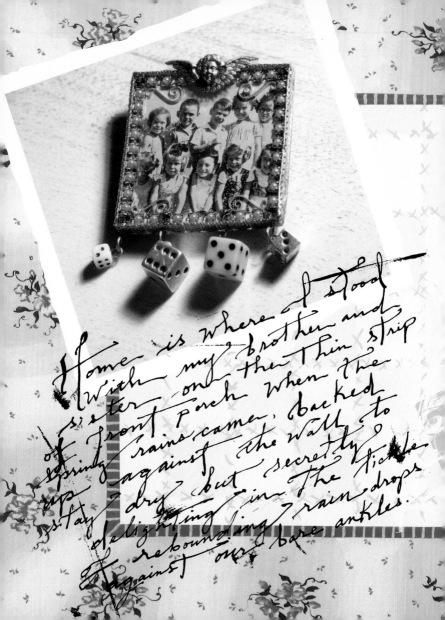

Home is where I stood with my brother and sister on the thin strip of front porch when the spring rains came, backed against the wall to stay dry, but secretly delighting in the fickle rebounding rain-drops against our bare ankles.

No house could hold

all my wonderful

memories of home.

That it will never
come again is what makes
life so sweet.

Emily Dickinson

Home is a living
memory book of
tears and smiles,
laughter,
whispers, song.
Home is where
honesty and realness
hold forth.
At home, we know
and we are known.

CREAM CARAMEL
(Crème Renversée Caramel)

2 cups milk
¼ cup sugar
3 eggs
2 egg yolks

1 piece vanilla bean (or a little extract)
2-3 tablespoons caramel (page 297)

Scald milk with vanilla bean. Mix together eggs, egg yolks and sugar, working them up until well combined. Remove vanilla bean (or extract) and pour hot milk gradually into egg mixture. Stir until combined. Line 6 custard cups or 1 large baking dish with caramel, sugar made by melting ½ cup sugar in ¼ cup water in a saucepan and cooking it until it turns golden color. When the caramel has set, pour the custard mixture on top of the caramel and place in a pan of hot water. Bake in a moderately slow oven of 325 to 350 degrees until custard is set. Allow 45 to 50 minutes for large dish or 20 to 25 for individual ones. When done, a small pointed knife inserted in the center should come out clean. Cool and unmold on serving dish. Serves 6.

CRÈME BRULEE

Follow recipe for Cream Caramel (above) but instead of lining the custard cups or mold with caramel, mix ¼ cup of caramel into the custard and reduce the amount of milk by ¾ cup.

SMALL VANILLA CUSTARDS
(Petits Pots de Crème Vanille)

2 cups milk
½ cup granulated sugar

6 egg yolks, beaten
1 piece vanilla bean (or a little extract)

Scald milk with vanilla bean and sugar, cool slightly and then combine with egg yolks, stirring constantly. Strain through a fine sieve and fill small custard cups. Set in pan of water, cover pan and bake in a moderately slow oven of 325 to 350 degrees about 15 minutes or until a small pointed knife inserted in the center comes out clean. Serves 6.

SMALL CHOCOLATE CUSTARDS
(Petits Pots de Crème Chocolat)

1 pint milk
18 egg yolks

½ lb. sweet cooking chocolate, grated

Scald milk, add chocolate and cook, stirring constantly, until it is

[254]

I have more memories than if I were a thousand years old.
—Charles Baudelaire

My home is more than a place to live; it is the one place where I can truly create. It is my blank canvas, and all is possible here.

Every room, doorway, and ray of light is left to my discretion. I am the artist who makes my house home. I must see every nook and cranny with an artist's eye, so that all who enter will feel at home.

There is no ecstasy like that of creation. – Louis Auchincloss

I have found a language
That has no words
In patterns, Color, and
shape. There is a
Flavor... mmm.....
like Orange Cream Soda!
An Emotion
It Excites me!
It Calms me!
It Surprises me!

It's the mix, not the match!

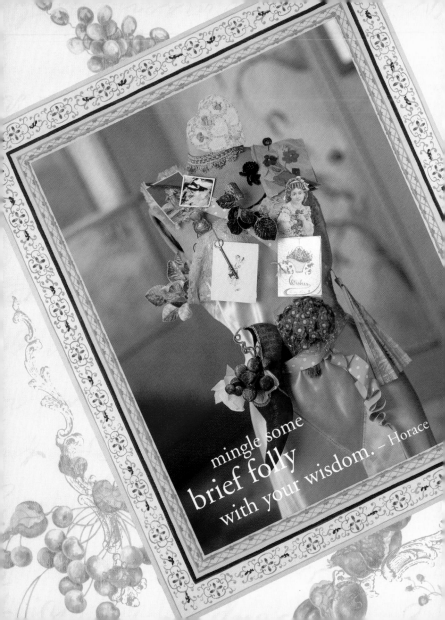

mingle some
brief folly
with your wisdom. — Horace

Living is a form of
not being sure, not
knowing what next or how.
The moment you know how,
you begin to die a little.
The artist never entirely knows.
We guess.
We may be wrong,
but we take leap after leap
in the dark.

— Agnes de Mille

*T*he purest and
most beautiful
minds are those
which love color
the most.

— *John Ruskin*

There is no reason either in prose or in rhyme, why a whole house should not be a poem.

— Ella Church Redman

Courage is not the absence of fear
but rather the judgment
that something else
is more important than fear.
—Ambrose Redmoon

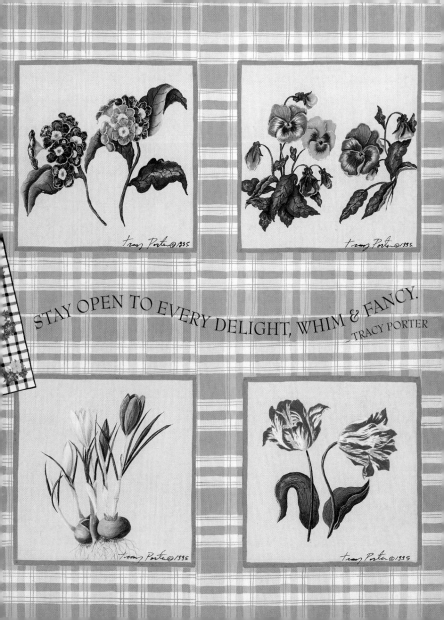

STAY OPEN TO EVERY DELIGHT, WHIM & FANCY.
—TRACY PORTER

Simply be aware

of the oneness of things

— Lao-tzu

I grew up on a gentleman's farm, and to a farm I have returned. Each new morning I am greeted by the familiar sounds of my upbringing. The animals of the farm, especially, return to me the comfort of where I was raised. Clyde, the proud rooster, greets each sunrise; the sheep bay in the evening calm. I am humbled by the dependent lives of our animals. They offer chaos and complete peace. I am home.

FOLLOW NOT ME, BUT YOU!

—FRIEDRICH NIETZSCHE

The
moments of
freedom. They
cannot be given to you;
you have to
take
them.

—Robert Frost

Go home
and take care
of what you have.
Provide places
for all
your things.

— Mother Ann
Shaker Foundation

One ought, every day at least, to hear a little song, read a good poem, see a fine picture, and, if it were possible, to speak a few reasonable words.

— Johann Wolfgang von Goethe

All things
are literally better,
lovelier, and more beloved
for the imperfections which
have been divinely appointed...

— John Ruskin

The ornament of a house
is the friends who frequent it. - *Emerson*

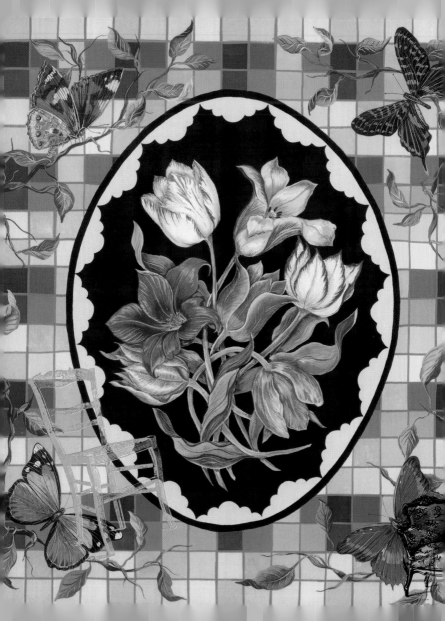

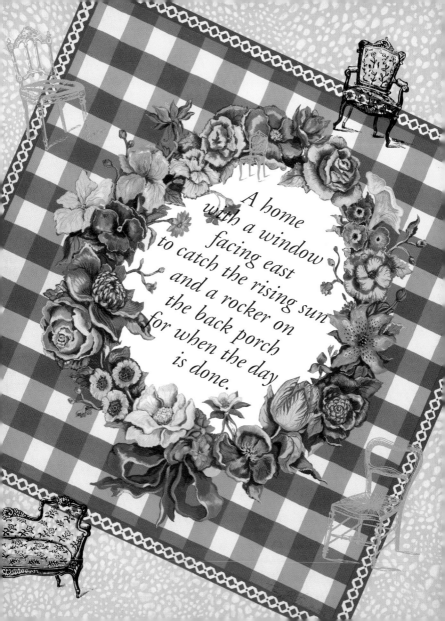

A home
with a window
facing east
to catch the rising sun
and a rocker on
the back porch
for when the day
is done.